GLAMOUR

DOS & DON'TS
HALL OF FAME

Fifty Years of Good Fun and Bad Taste

GLAMOUR
DOS & DON'TS
HALL OF FAME

Fifty Years of Good Fun and Bad Taste

Edited by Joanne Mattera

Villard Books / New York 1992

ISBN 0-679-74233-6.

1. Costume—United States—History—20th century. 2. Fashion—United States—History—20th century. 3. Fashion—United States—Humor. 4. Glamour—History—20th century. I. Mattera, Joanne. II. Glamour. III. Title: Dos and don'ts hall of fame.

PRINTED IN MEXICO

Acknowledgments

Many people have been responsible for "Dos & Don'ts" during its 50-year history. To Editor-in-Chief Ruth Whitney, who has been at the helm of *Glamour* for 24 of those years, goes credit for the tone—a sense of sisterhood that lets us have fun without making fun. Because, really, who else but your sister (or maybe your best friend) could hold a mirror to you the way we do and get you to laugh about it?

In past years, many editors, including Suzanne Eaton and Cheri Crump, have gone into the street with photographers. More recently it's been Christine Fellingham, whose on-the-mark captions are as infallible as her eye. Senior Fashion Editor Kim Bonnell keeps a balance between the plausible and the unbelievable (because the unbelievable really is out there).

The biggest thanks go to our photographers—we're not naming names, are you crazy?—and to the good sports in curlers and crinolines, swimsuits and business suits, bell-bottoms and cropped tops, we've put on our pages.

Finally, this is a personal thanks to *you,* on the very real chance that we'll catch you making that fashion faux pas you'd rather die than be caught making . . . or at least tugging at your underwear.

Introduction

Glamour's "Dos & Don'ts" is a tongue-in-chic history of the fashion sense—good and bad—of American women of the past 50 years. Who would have guessed that our observations would become a must-read and that "Don't" would become shorthand for "fashion disaster"?

If there's a constant, it's that the Don'ts are consistently bad. Looking back from a contemporary perspective, so are a good number of the Dos. The *Saturday Night Fever* bell-bottoms and platforms we applauded in December 1972, for instance, now strike us more like Saturday night flu. But a good Do is a classic.

What makes a woman a Do? She's confident in what she's wearing. She's comfortable in her clothes. Take "the ideal girl" of November 1966: Fresh in an A-line shift with a scarf in her hair, she could turn up tomorrow without looking out of date. Even when she's cutting edge and trendy—typically the route to Don't-hood—the Do is in control; her clothes never look as if they are wearing *her*.

What makes a Don't? She's the overdo, the one who's wearing too tight, too short, too long, too bright. Her hair's too big. Her makeup's too in-your-face. She doesn't know when to stop. Or in the case of the too-plain Don't, she doesn't know where to start. Our job, of course, is to catch her—or you—on the day nothing falls into place. That's part of the fun of "Dos & Don'ts": You never know if we'll get you—or when. Some days we turn the camera on ourselves; we have bad days, too.

Beyond the obvious amusement of five decades of good fun and bad taste, we found something more enduring. We found a history of women coming of age. First there was the progression of fashion for real life: forties shoulder pads, fifties shirtwaists, sixties miniskirts, seventies platforms, eighties dress-for-success suits, nineties pantsuits. Then there was the intersection of those fashions with real life: women in the workplace during World War II, a return to the home, then a return to the workplace as women became increasingly comfortable with their power to shape their own lives. "Dos & Don'ts" never set out to make a political statement, but like the background of a photograph that turns out to be as telling as the subject of the photo itself, the image of an independent woman has emerged.

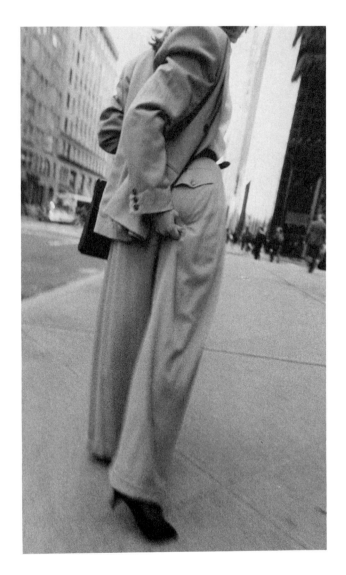

One thing you just don't do in public: tug at your underpants, because no matter how discreet you *think* you're being, someone always catches you in the act. We've seen this woman numerous times. It's not you, is it?

Chapter 1

Before the Black Bar

"Dos & Don'ts" appeared for the first time in April 1939, in the very first issue of *Glamour*. The idea: "to bring some of the light and life of Hollywood to your wardrobe." No black bars here. How could we, with the reigning queens of the movies as our role models? "Do borrow a bit of the Crawford drama by pinning lilies-of-the-valley to your evening frock," we suggested in our "Fashions from Hollywood" feature. Corny by today's

April 1939

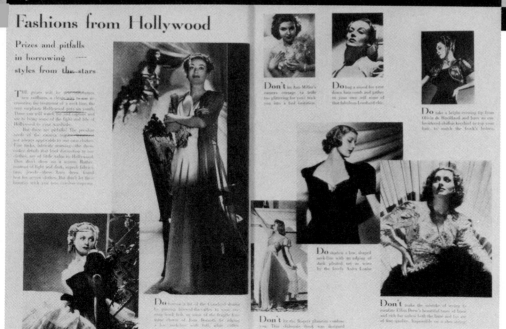

Fashions from Hollywood

Prizes and pitfalls in borrowing styles from the stars

◄
"Dos & Don'ts" debuts with such models of Do-hood as Joan Crawford, Joan Bennett and Olivia de Havilland.

standards, the fashions and our promptings surely brought a sense of the exotic to women who spent the day in cotton housedresses and ankle socks.

"Do take a bright evening tip from Olivia de Havilland and have an embroidered chiffon kerchief to top your hair." So much the better if it matches your bolero. And while you're at it, "Do bag a snood for your hair." But borrowing from the stars was not without pitfalls, as we illustrated. A pitfall: "Don't let the Rogers glamour confuse you." Ginger's elaborate frock was designed for a spectacular dance number with Fred, "not for your evening wear." But wasn't that the point? If you couldn't dance with Fred, or dance as well as Ginger, at least you could emulate the dress. And if you had any intention of emulating Ellen Drew's "rich" lamé and fur tunic, forget it, we said: "Impossible on a shoestring." Well, excuse us.

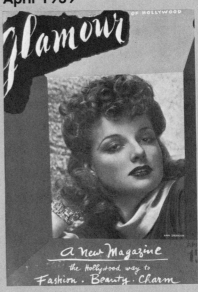

►

The first issue of *Glamour*. Actress Ann Sheridan is on the cover; the first "Dos & Don'ts" is inside.

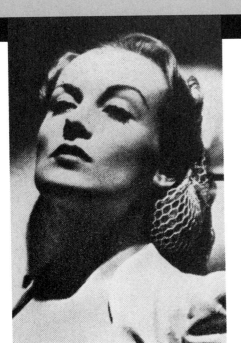

◄ "Do bag a snood for your hair," we said. The Do: Carole Lombard, absolutely glamorous. But can't someone come up with a better word than *snood*?

The first time "Dos & Don'ts" ► appears in a title. And the only time we'll tell you that a lace mantilla gives you "a fragile, cherished look."

The next month we were back with "Fashion Dos and Don'ts from Hollywood." "Do throw a filmy lace mantilla over your curls." (That's a young Bette Davis looking filmy under the mantilla.) And by all means, "Do have a tiny lace fan and look like a coquette."

Although it appeared two months in a row, "Dos & Don'ts" didn't return again until a year later. In a May 1940 spread, we focused on hats. Dorothy Lamour's felt fedora was a Do; her big, inflated pancake of a beret, a Don't. "If you're career bound, don't copy this hat or hair," we said of the beret. Fair enough. We'll spare you details of the turbans and curlers Dorothy shared the page with.

"Dos & Don'ts" took a vacation until the mid-fifties. In June 1957, "Dos & Don'ts" turned up on the cover, promising plenty of fashion and beauty tips for summer. Some of them still hold: "If you're wavering between a conservative party dress and one that's brilliant, don't be timid." Now, we might just suggest that your next little black dress be, say, fuchsia.

May 1940

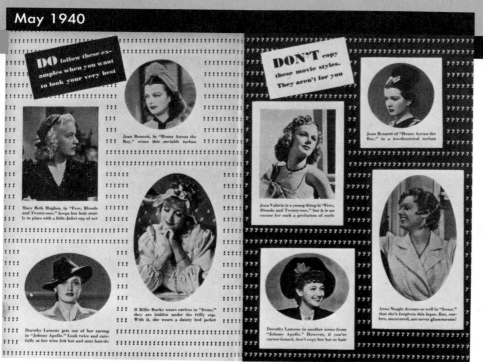

◄ We were still developing the idea of "Dos & Dont's." The exclamation points and question marks on the background are our first and only graphic depiction of the concept.

And long before anyone knew anything about ultraviolet rays and skin damage, we said, "Don't feel obliged to get a tan."

Sometimes we stuck with the concept of "Dos & Don'ts" without following the format. Take the overdrawn Joan Crawford lips in a September 1958 feature: We just said "No." As with our own sense of fashion and politics, "Dos & Don'ts" left the fifties evolving.

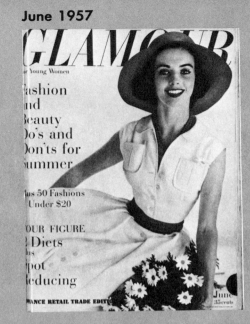

"Dos & Don'ts" gets a cover line. ▶

June 1957

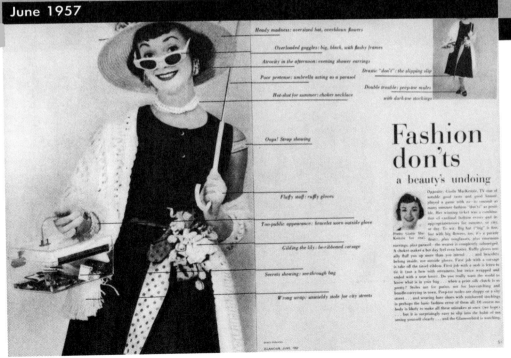

◀ We spoofed the Don'ts of the day. Some faux pas have continued for real, like crocheted granny stoles (you'll see as the time line continues) and the bra strap that seeks the light of day (you'll see this on the street today).

The 60's

This was the Age of Aquarius and the Decade of Change. It started with June Cleaver and ended on the eve of Woodstock. Our clothes mirrored our politics as we slipped from uptight to hang loose, as headline coverage of the Cold War gave way to heated debates about the sexual revolution. This was also the decade of hair—the play, the song, the real stuff—and we went from teased to long to down-past-the-waist. Skirts? We went from long to short. Style? From Jackie Kennedy elegance to the hippie decadence of love beads and bare feet. This was the era of Twiggy as an ideal look, and "twiggy" as a body ideal. It was the era of fringed leather and fringed eyelashes, of hip-hugger pants and bell-bottoms you could pitch like a tent.

Politically it was an era in which we looked past our backyards and into the world. The civil rights movement changed the way we related to humanity and, in so doing, changed our own humanity. We marched to change the world.

February 1963

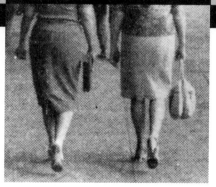

DON'T We called the skirt on the right "too short," the one on the left "too long." Talk about limited options.

The Way We Wore

February 1963

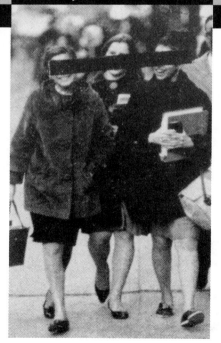

◄ **DON'T** The first black bar! The fashion faux pas? According to our guidelines: "skirts too short." We were about to take up our thinking on hemlines.

DON'T We called these ► stretch pants "splendid for skiing but not for walking to class." Now, on a body like this, they're splendid on or off the slopes.

In fashion as in politics, nothing went unchallenged. It was the first taste of freedom for many women.

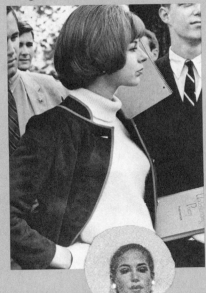

Girl to Woman

The sixties were as much about *evolution* as *revolution*. Take this coed (that's what female students in higher education were called when they were still a novelty): She was one of the "Ten Best-Dressed College Girls." In the seventies and eighties, this category would evolve into the achievement-oriented "Top Ten College Women"—a triumph, academically at least, of substance over style.

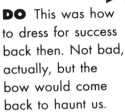

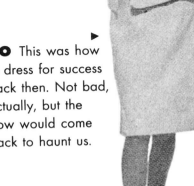

August 1963

August 1963

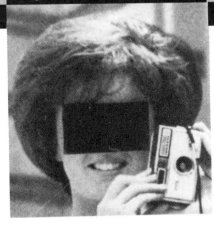

May 1964

DO This was how to dress for success back then. Not bad, actually, but the bow would come back to haunt us.

DON'T On campus to shoot Don'ts, we were caught in the act. But we had the last word. We pronounced her teased hair "out."

The Original Conehead?

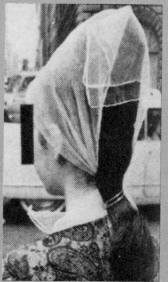

Our advice was sensible if shrill:
"Never, never tease your hair
this much, and never wear a
scarf this way."

September 1965

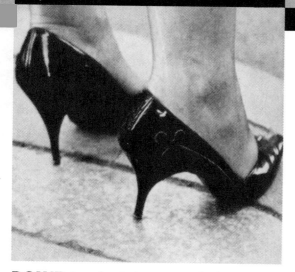

DON'T Low heels became a fashion option
for women over 12. We called these shoes
"stilts" and suggested you slip into something
more comfortable.

January 1966

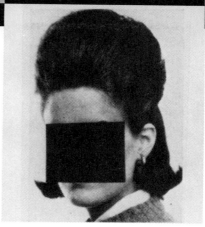

DON'T Seventy percent of the
women in every high school
yearbook had hairdos exactly
like this. Hair spray was the
number-one fashion accessory.
(White lipstick was the second.)

January 1966

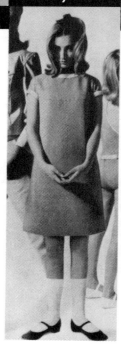

April 1966

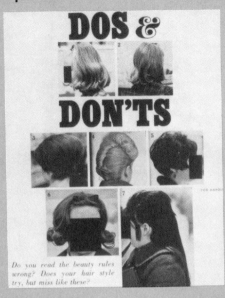

Hairdos from Hell

Teasing was an apt term for what was done here, because each hairdo gave a big *nyah nyah nyah nyah nyah nyah* to good taste.

November 1966

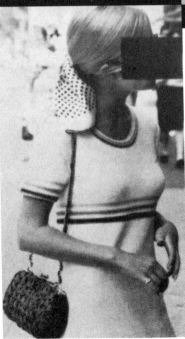

December 1966

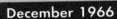

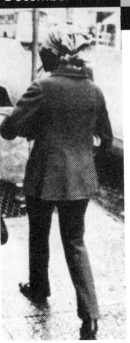

◄
DO So what was the option to ratted hair (and its corollary, too-tight sweaters and skirts)? The Twiggy look here. In retrospect, dressing like a three-year-old was not such a great alternative.

►
DO We called her "the ideal girl." With her sleek hair and fuss-free minidress, she was the quintessence of sixties style.

DO "The problem ► is no longer where or if to wear pants, but how," we wrote. We pronounced this pantsuit just right in shape and proportion.

Roll'em

Going out looking like a radio transmitter was always in bad taste, but what we find amusing is that anyone thought a scarf would actually cover up the indiscretion.

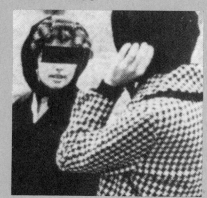

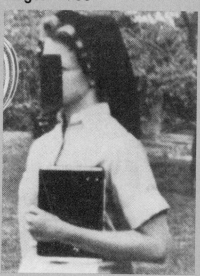

March 1967

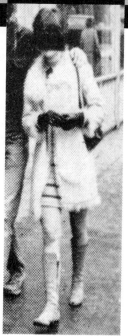

May 1967

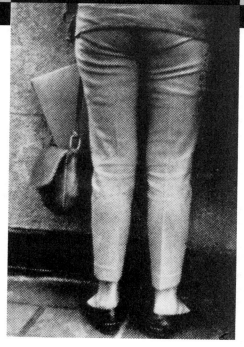

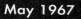
DO With its short skirts, slim lines and kicky boots, Mod style—imported from Carnaby Street in London—invited disaster. However, this young woman did it right.

DON'T How not to wear ▶ pants: too tight and with no thought to the rear view. A Don't then, now—and forever.

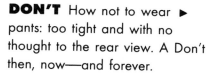

June 1966

November 1966

July 1973

May 1967

June 1967

August 1967

DON'T We were appalled by the sight of this woman combing her hair in public. Considering the amount of teasing and spraying that went on to maintain the mega-dos of that era, running a quick comb through the hair seems almost, well, tasteful.

◄ **DON'T** This was not a trend we liked. We said, "The only place bell-bottoms should be seen is on a boat." Guess who missed the boat?

DO A classic is ► worn. The trench has shown up dozens of times through the years. And with good reason: There's no more versatile coat.

Déjà Don't: Pack Animals in a Previous Life

The beast of burden spotted in the sixties, *right,* was reincarnated in the nineties pack animal, *far right.* The only difference: the folkie guitar was replaced by the yuppie attaché.

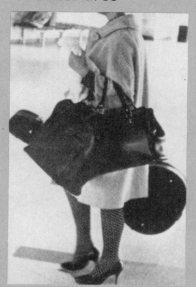

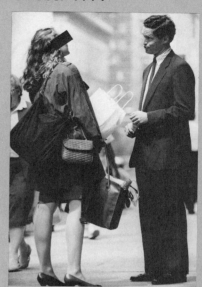

October 1967

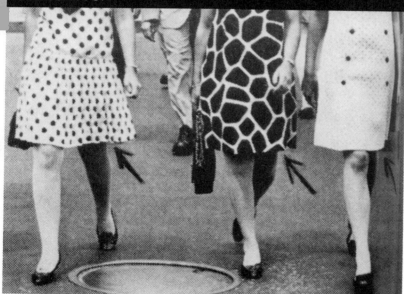

DON'T We said these hemlines did nothing to flatter, but with the clown dots and giraffe patterns here, length hardly seems the issue.

February 1968

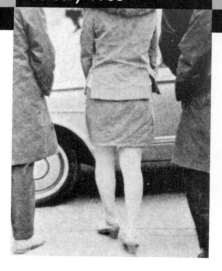

DON'T Apprehended by the fashion police? It only seems that way. But we were ready to run her in for this ill-fitting suit.

November 1965

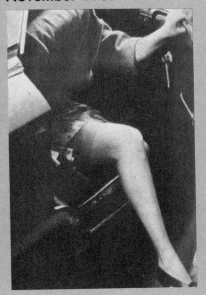

Déjà Don't: Auto Eroticism

◄ When the first wave of miniskirts appeared in the sixties, getting out of a car revealed more than was intended.

History repeats itself. Nothing's changed. ►

October 1991

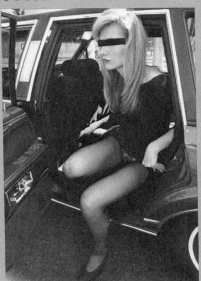

May 1968

DON'T Jeans and loafers were all right for campus but, we said, too casual for city streets. Boy, were we wrong.

August 1968

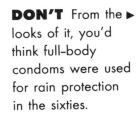

DON'T From the ► looks of it, you'd think full-body condoms were used for rain protection in the sixties.

◄
DO We said she looked "perfectly pulled together" for a city campus. Considering that the style on most campuses consisted of scraggly hair, bell-bottoms, bare feet and love beads, perhaps this look was a weensie bit uptight?

September 1968

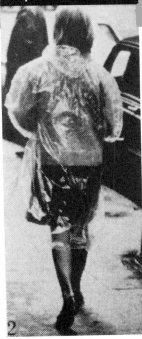

Is That a Bread Wrapper on Your Head?

It's hard to believe that bad taste could persevere in the same form through three decades, but the little accordion rain cap turned up many times throughout the sixties, seventies and eighties.

September 1968

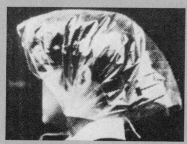

January 1978

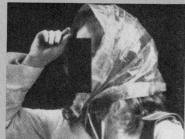

March 1981

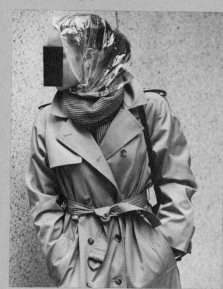

January 1969

◀ **DON'T** Talk about optic nerve! This was not what The Beach Boys had in mind when they sang "Good Vibrations."

DO The hippie look goes ▶ mainstream. Down the river is more like it, but we liked her textured stockings and "neat little satchel bag."

March 1969

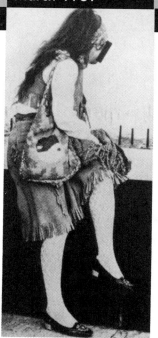

July 1969

Either the Eyes Have It, or They Don't

If we were to rewrite our makeup advice, it might go something like this: DO apply eyeliner and mascara lightly so that the lid and lashes retain a relation to the brow bone and eye socket. DON'T put your makeup on so heavily that you look like a 2,000-year-old queen.

August 1966

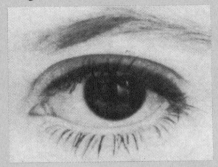

DO

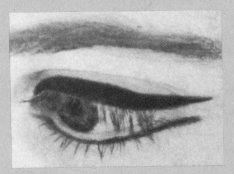

DON'T

September 1969

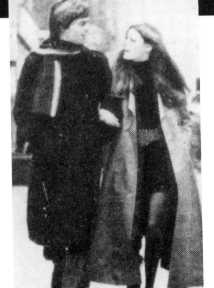

◄
DON'T We called this woman a Don't because she was overdressed for cycling. We were too kind.

DO The era of the maxicoat ► overlapped with the miniskirt, and this young woman looked great.

October 1969

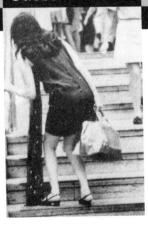

DON'T Long on style, short on sense. We also spotted women with scarves in the trash, in the soup and caught in a revolving door. Alas, the lesson of Isadora Duncan went unheeded.

The 70's

Although it tripped in barefoot from a summer of peace and love, the seventies stumbled out in square-toed oxfords and dirndl skirts. In between there were granny dresses, granny squares and granny glasses. Layers—and layers—to keep warm during the energy crisis. Earth shoes and clogs. No wonder this is remembered as the Dowdy Decade.

There was some fun. Afros inflated to beachball proportions for both sexes: think Angela Davis, Roberta Flack, *The Mod Squad*. The shag—remember *The Partridge Family* and Jane Fonda in *Klute*?—was another unisex do.

Unisex became a Do. Girls and boys clomped around in six-inch platforms and sported seven-inch lapels. Everyone wore jeans and anything denim. Diane Keaton's *Annie Hall* look was a jumble of untucked shirt, oversize vest and loosened tie, while menswear Mod had the guys dressing like peacocks. Meanwhile, guess whose closet was filling up with pants?

July 1971

August 1971

October 1971

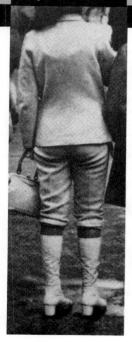

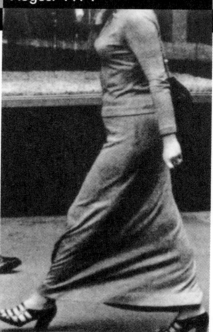

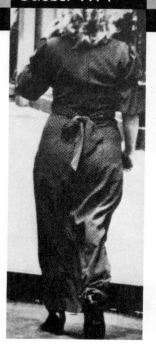

◄ **DON'T** Our problem: The tops of this woman's boots didn't meet the bottoms of her knickers. Her problem: she looked more like a schoolboy than a grown woman.

DON'T Was it the ► length of the skirt we found too extreme for daytime? No, it was the "dressy sandals."

February 1970

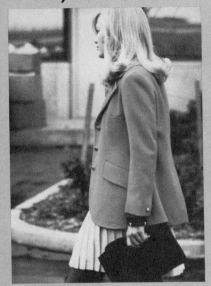

Déjà Do: Getting the Scoop

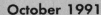**October 1991**

◄ Diane Sawyer was a young reporter in Louisville. We called her "practically a one-woman news team," and said she looked great "no matter which side of the camera she's on."

Our opinion hasn't changed. Twenty-one ► years later, we named this nationally recognized newswoman to our first "Do Hall of Fame."

December 1971

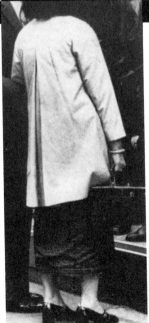

January 1972

◄ **DON'T** This was the era when twentysomethings dressed like their grannies. "In a time when almost anything goes," we wrote, "some looks go too far."

DON'T Styles change, but ► three things remain constant: proportion, proportion and proportion. This unfortunate dresser missed on all three counts.

DON'T Although ethnic dressing was the way to go, this nomadic look seems to have lost its way.

August 1970

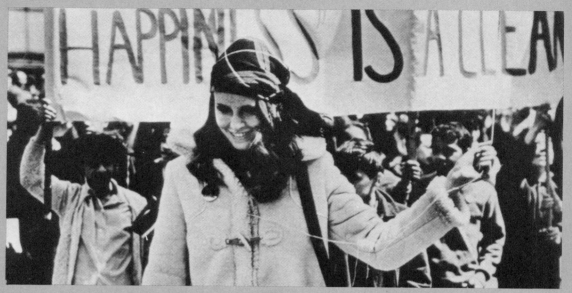

June 1972

DO Dressing for success was not yet a concept, so this working woman—er, "working girl"—was dressed just right.

September 1972

◄
DO You could have stuffed a crinoline into each leg of these pants, but that was the style. We called this shot "a good example of how the right pants and shoes can work together." *What shoes?*

November 1972

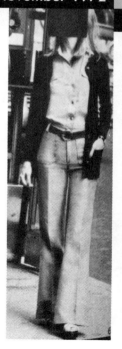

DO Early seventies style ► consisted of skinny tops and floppy legs. Given the silhouette, this woman looked great.

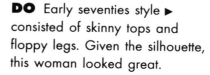

Déjà Do: Cycle/Recycle

◄ One of our Top Ten College Women winners participated in an Earth Day celebration.

May 1990

► Two decades later, eco concerns resurface. Wearing a T-shirt, this woman is up front about environmental awareness.

December 1972

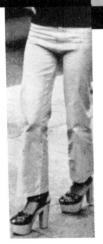

March 1973

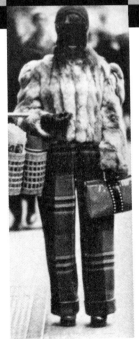

March 1973

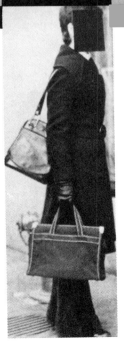

DON'T Would you believe we nixed this look only because the pants were too short? Many women fell off their platforms that year.

◄ **DON'T** Clothes like this explain why the seventies has been called the Dowdy Decade. So was it the chubby jacket we objected to? The fit-a-friend-in-your-pants trousers? The four-inch cuffs? No, it was the straw bag.

DO We called the canvas ► carryall in this picture "neat and in proportion" to the clothes. Would that have been in proportion to the seven-inch collar or the flap-in-the-breeze pants?

June 1963

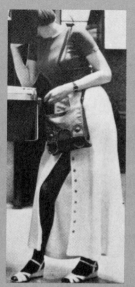

Déjà Don't: Slit Personality

Some fashion errors are destined to repeat themselves. Witness the slit skirt, which has gone through three decades of dysfunctional style. Unbutton/unsnap too much and you run the risk of turning into a sideshow.

September 1984

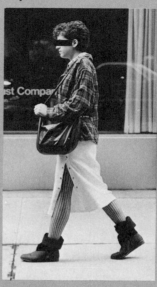

April 1992

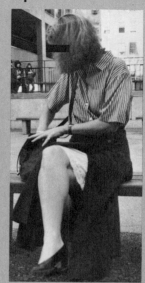

April 1973

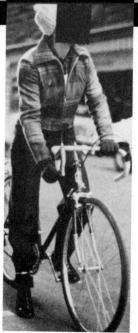

◄ **DO** We called this look "super" for cycling. But it was super in other ways, too. The slim pants and neat little jacket gave this woman the freedom to get around, whatever her mode of transportation.

DO If there was a look for this period, it was long hair and aviator glasses. This young woman personified it. ►

May 1973

September 1973

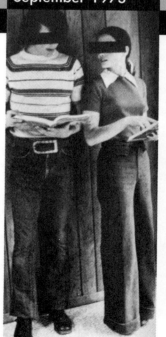

A Do or a Don't?

Times change, and so do our fashion judgments. How did we call these two knotted-at-the-midriff looks? (Hint: It's a tie.)

April 1971

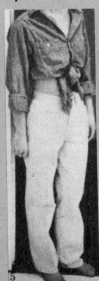

▶ We called this shirt "far too big." Translation: a Don't.

May 1992

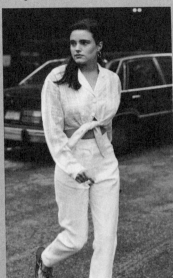

◀ We said, "Tied equals chic." In other words: a Do.

May 1974

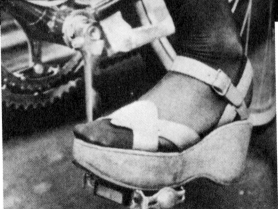

◀ **DO** We said this campus couple looked "pulled together." A Mod version of Raggedy Ann and Andy comes to mind. And what happened to her feet?

DON'T We nixed these sandals because the soles were too thick for cycling. On the sidewalk, however, they were de rigueur that year. Footnote: Sandals of this style were called "water buffalos." Was it the source of the leather? Or the way we looked in them?

July 1974

DO We said this was how to dress for work on Friday if you're skipping out early for the weekend. If you dress this casually now, don't expect a job on Monday.

Déjà Don't: Tied for Last Place

A fresh idea gets twisted out of shape in two different decades.

May 1992

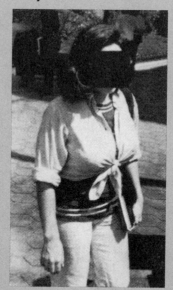

August 1973

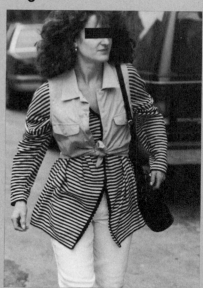

August 1974

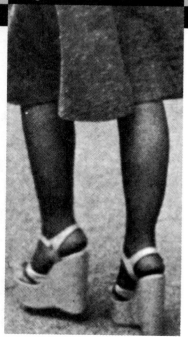

◄
DON'T "High-platformed shoes may be okay for some things," we wrote then, "but not this longer-length skirt." Exactly what "things" would shoes like these have been okay for? Reaching the top shelf in your kitchen? Dusting the ceiling—with your hair?

DON'T What hasn't changed: the cutoffs. Now, though, the Don't would wear them with black tights and cowboy boots instead of argyles and platforms. ►

September 1974

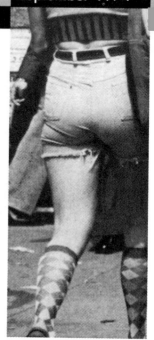

DO We described ► this look as "easy but polished" and pronounced it "smashing." A Do then and now.

Which Look Is the Do?

Two pairs of platforms, two pairs of bell-bottoms with enough billow to make a mainsail. Which did we call the Do?

December 1972

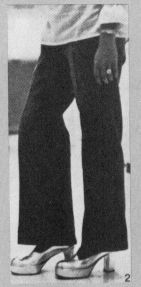

◄ We liked the shoes. It was the pants—"too short and too skimpy"—that made this look a Don't. *Skimpy?*

April 1972

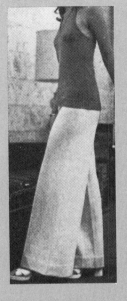

We praised the "sleek line" of ► these pants. Plus they cover a bit more of the shoe. You guessed it: a Do.

October 1974

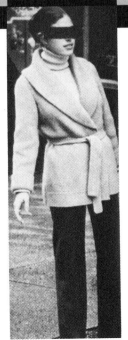

October 1974

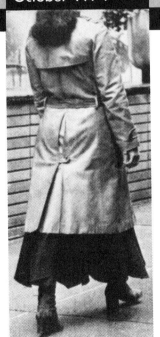

◄ **DON'T** Don't blame the trench coat for the faux pas here; it's that extra eight inches of skirt hanging out the bottom.

DON'T Longer pants or ► lower heels would have solved the problem here, which at the time was too much visible sock. Why we would have wanted the equivalent of a skirt flapping at each ankle is another question.

October 1974

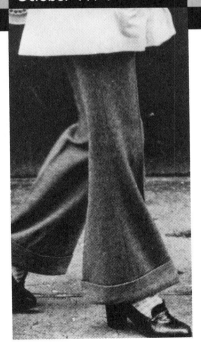

October 1972

Déjà Don't: Is That a Bedspread on Your Shoulders?

Granny glasses spanned the generation gap, but granny's shawl—bedspread? tablecloth?—just doesn't work for anyone under 80.

November 1974

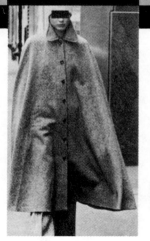

January 1975

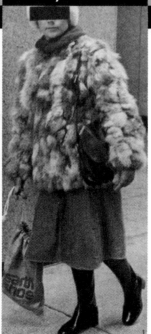

March 1975

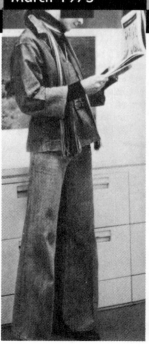

◄ **DO** What could we possibly have been thinking when we gave the nod to this fuzzy-wuzzy? Besides the patchwork possum, it's Slim-Fast in reverse—an extra 15 pounds instantly.

DO We called this cape "a simple, uncluttered look." Right, if you don't have arms cluttering up your torso.

DO This proportion—slim on top, belled on the bottom—persevered. We said it was the best way to wear denim. And it was—then. ►

December 1973

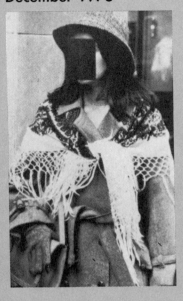

April 1984

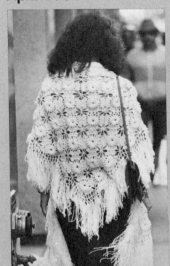

December 1985

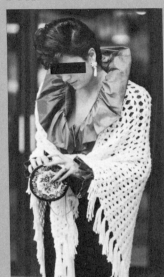

June 1975

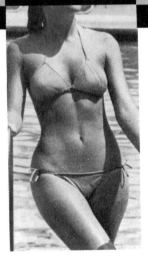

August 1975

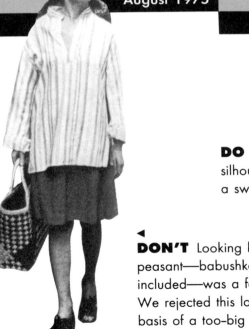

September 1975

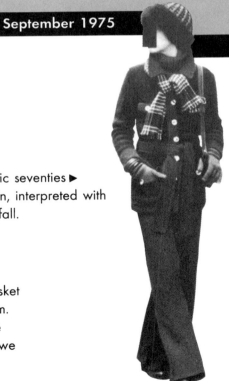

DO The classic seventies ▶ silhouette again, interpreted with a sweater for fall.

◀
DON'T Looking like a peasant—babushka and basket included—was a fashion aim. We rejected this look on the basis of a too-big shirt, but we needn't have stopped there.

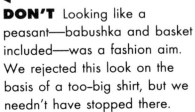

DO This is how to look in a bikini. A Do then and now. We'll spare you the Don'ts.

April 1972

April 1972

Crowning Gory

Whether it's piled on the head or bunched into a knotty cascade, hair like this, we said, is "contrived and overwhelming."

March 1976

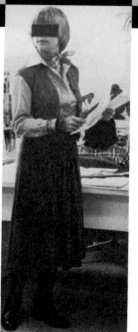

August 1976

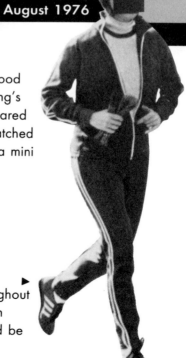

November 1976

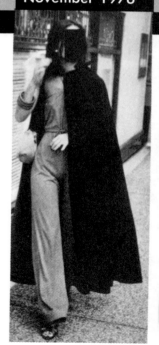

◄ **DO** We called this "a good office Do." Well, everything's relative. The Don'ts she shared the page with included patched jeans, a granny skirt and a mini that looked like a tutu.

DO After marching throughout much of the sixties, women realized that running could be equally beneficial. ►

April 1972

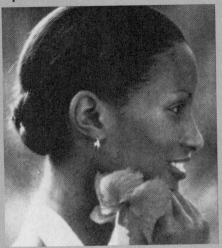

July 1973

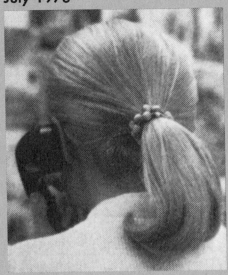

Crowning Glory

We've been through Afros, braids, curls and fades, beehives and Farrah wannabes; some worked, some didn't. These sleek hairdos worked then and now.

January 1977

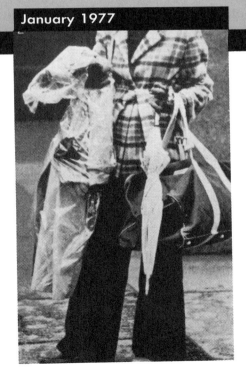

February 1977

◄
DO The cape as a solution to how to cover up in the evening. And look, arms!

▶
DON'T Pack-animal sighting. The amount of stuff she schlepped should have refuted the notion of woman as the weaker sex.

DO The layered look was devised during the energy crisis. The idea was to combine as many strata of clothing as possible, for warmth. We called this look "polished." It should have been sandblasted.

Caution: Heavy Load

These women are overweight. But we're not talking bodies; it's their cargo adding the extra pounds.

DON'T Nice touch: a shoulder bag slung under the neck like a feedbag.

March 1981

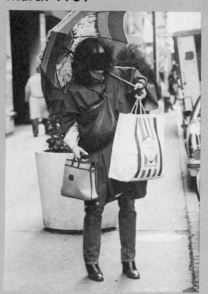

September 1982

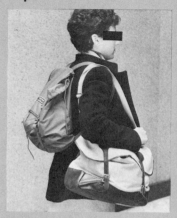

DON'T Some people walk a mile for a Camel. Others walk that mile *like* a camel. Lighten up!

February 1978

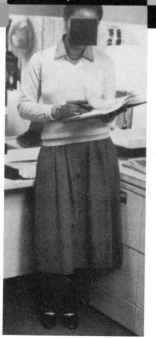

◄ **DO** We called this sweater and skirt "a well-planned look" for work. Sure, if you're planning to stay next to the Xerox machine forever.

DO Running two-for-two with the work look at left, we called this peasant blouse and skirt "professional." Maybe, if you're a serf. ►

March 1978

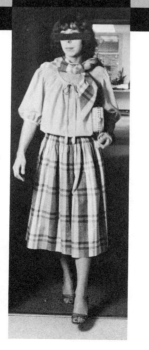

July 1978

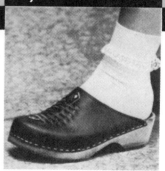

DON'T Precursors to platforms, clogs remained popular with a handful of fashion iconoclasts: leftover hippies, college students and anyone who preferred the comfort of shoe boxes to actual shoes. The Don't here: wearing the wooden-soled slip-ons with ankle socks.

February 1986

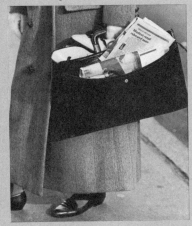

DON'T You don't need to carry more than one bag to look overburdened.

August 1988

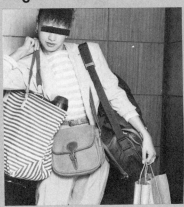

DON'T Two arms, four bags. Unless you're willing to wear saddlebags or a yoke, these are too many packages for one person.

March 1992

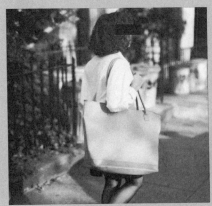

DON'T The good news: She's down to one bag. The bad: If she fills it, she'll list like the *Titanic* just before it went down.

August 1978

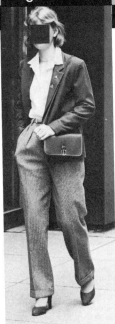

◀ **DO** Pants go to work. Not every dress code allowed them, but this confident woman was in the vanguard.

DON'T Combination ▶ clog, platform and mule, this high-heeled atrocity could have been meted out as punishment. Its wearer was more than a Don't—she was a walking danger zone.

August 1979

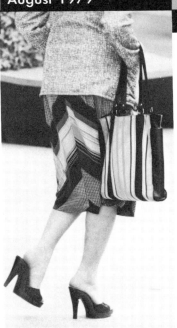

October 1979

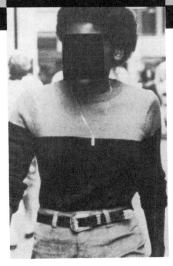

DO How to wear a casual sweater? As simply as possible. This no-nonsense woman illustrates how less is more.

Chapter 4

The 80's

This was the era of "dress for success." We donned boxy business suits and that limp lasagna of a tie and convinced ourselves we looked good—until we glimpsed our image in the mirror or got to work and saw a dozen of our colleagues looking exactly like us (including the men). Fitting in was one thing—fading out was another. But there was a direct correlation between insecurity and the degree to which we blended into that sea of navy suits, so it's a good reflection on us that by the end of the eighties we were back to looking like the individuals we are. We traded those clone suits for dresses, shaped suits and a name on the door. Success!

Later in the decade came dressing to excess. Modern-day Marie Antoinettes were decked out in pouf skirts and overdosed on designer accessories purchased, no doubt, with all of that precrash, megadeal cash. But excess was not limited to a five-figure wardrobe. Consider ripped and shredded jeans, which metamorphosed from Don't to Do. And what about shoulder pads? Not just the hefty foam wedges we stuffed into our blazers

March 1980

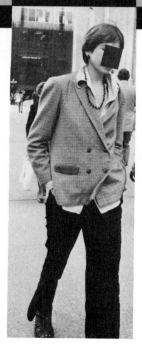

◄ **DON'T** Then as now, casual didn't mean sloppy. This woman's blazer should have completed her look, not covered up the lack of one.

DO She was the height of ► preppy styling, from the snout of her alligator to the tip of her penny-loafered toes. We thought she was "neat."

June 1980

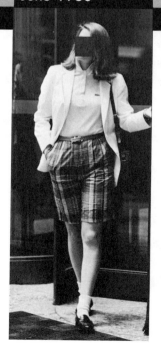

August 1980

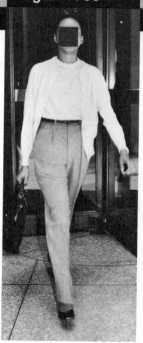

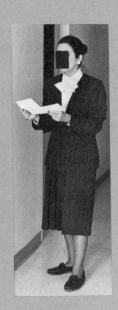

but the cumulative effect of blouse plus blazer plus coat. The effect was a permanent shrug—to say nothing of a fire hazard. Not surprisingly, padded-bra sales during this era were down. How much upholstery could one body pack, after all?

The Way We Worked

February 1981

Yes, one of these was a Do.

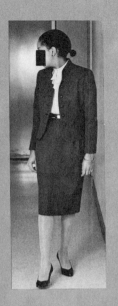

If this is dressing for success, imagine what dressing for repression would look like. It's the Don't—too uptight even for then.

Success! A "serious" suit with the beginning of style: a bit of shape, interesting details and a graceful jabot instead of that limp lasagna at the neck. ▶

DO In praise of alternatives to the jacket and skirt: "This handsome look has enough polish for almost every office." Still true. ◀

January 1981

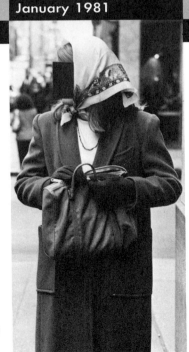

April 1981

DON'T Did she grow taller or did the pants shrink? Actually, it's not so much the three inches of sock we responded to, but the bracket of flapping trousers and those you-know-whats.

DON'T One year into the ▶ eighties and the effects of the Dowdy Decade remain. At least it's just the babushka.

Excuse Me, Your Slip Is Showing

Three things you can count on in fashion: Clothes aren't cheap, hemlines will change, and if something can go wrong, it will.

June 1989

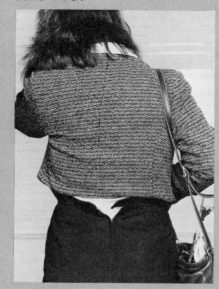

◄ The domino effect: After the button pops, the zipper heads south. At that point, you'd better find a pin.

April 1981

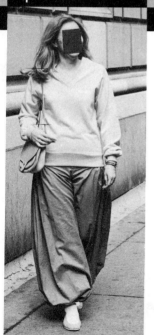

◄ **DON'T** And we complained about bell-bottoms? If the legs of these trousers had been filled with hot air, this woman could have crossed the Atlantic like a weather balloon.

DO The suit idea took hold in ► fits and starts. We proposed this sweater and skirt during one of the intervals.

May 1981

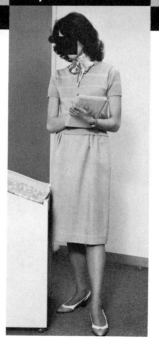

July 1981

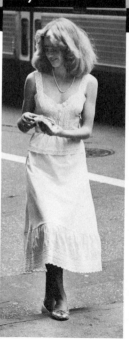

Seeing Through Clothes

See-through fashion can work—when inner and outer layers are planned. Here you see it, but it's a Don't.

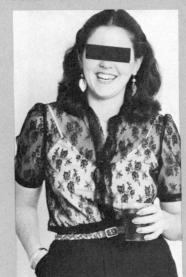

June 1990

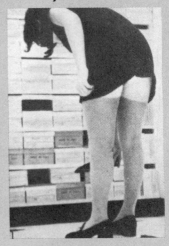

January 1970

This is not what is meant by the gender gap.

June 1974

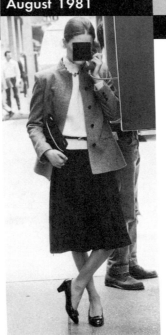

August 1981

◄
DO "Do wear a fresh white camisole and romantic skirt to town," we counseled. Too bad we forgot to tell you what to wear over them.

DO This work ensemble may be dated, but you can see its wearer was thinking about dressing for her job. ►

October 1981

DO This was a smart casual look, although if we had to do it over again, we wouldn't tuck the pants into the socks.

Variations on a Theme

The ideal undergarment is the one that remains *under* the clothes. Alas, is there a woman alive to whom this hasn't happened?

August 1985

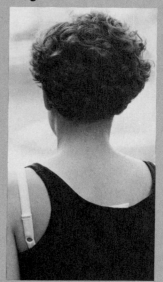

May 1977

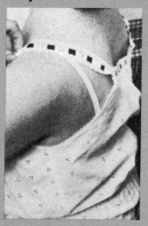

May 1975

July 1976

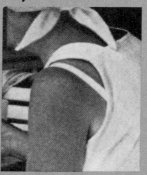

April 1982

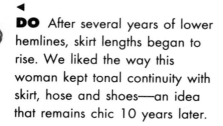

June 1982

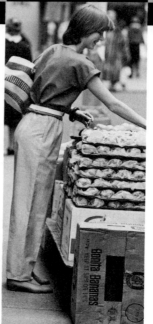

June 1982

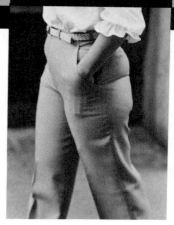

◄ **DO** After several years of lower hemlines, skirt lengths began to rise. We liked the way this woman kept tonal continuity with skirt, hose and shoes—an idea that remains chic 10 years later.

DO This was the era of ► "baggies," pants that gave you lots of room—more than you needed, really—in the seat and thighs. Our Do selected a pair that struck a balance between body and trend.

DON'T How not to wear pants. Part of the problem was the "chino" styling—too straight-cut for a womanly body. The other part was that they were just too tight.

Your Slip Really Is Showing

April 1982

Here's where a mirror can come in handy.

June 1990

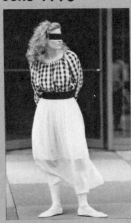

How to go from X-ray woman to normally dressed: Slip on a slip.

May 1975

August 1989

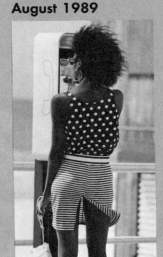

A Real Slip-Up

November 1982

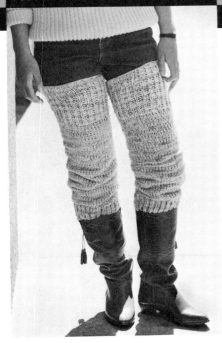

February 1983

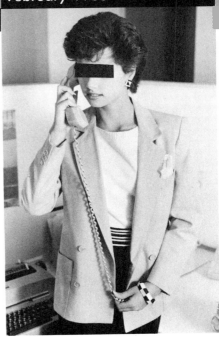

◄ **DON'T** After a brief infatuation with leg warmers, we realized they were best left in the dance studio, where they had a function. On the street, they're like wearing a sweater over your blazer.

DO Jacket dressing gets both ► easier (the blazer tops a knitted shell) and nattier (note the pocket square).

Fashion Schizophrenia

You'd think these women dressed from a Chinese menu—one from Column A, one from Column B.

We love man-tailoring with a ▶ feminine accent, or womanly clothes with a masculine touch, but here you don't know whether the emphasis is on Victor or Victoria.

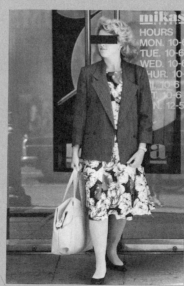

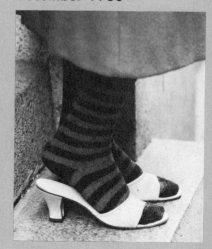

Heavy socks with mules: sort of like long johns under a swimsuit.

August 1983

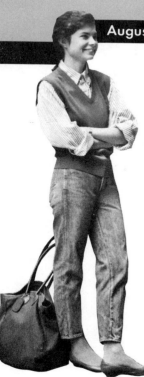

◀ **DO** A look at home in any decade, on either sex. That's why it's a classic jeans Do.

DON'T On the ▶ other hand, too-tight jeans and high heels are a classic Don't.

August 1983

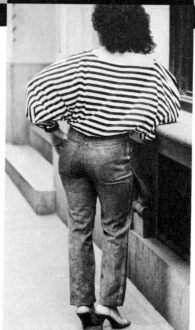

September 1983

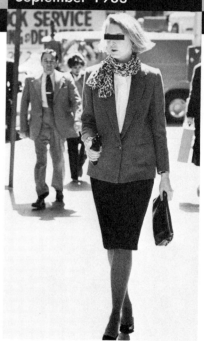

April 1982

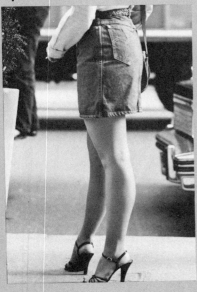

◄ Attention fashion travelers: This is not the planet on which a sporty jean skirt takes go-dancing sandals.

February 1981

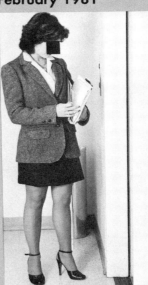

Unless you're an employee of ► Pumps-R-Us, these are the wrong shoes for a blazer and skirt.

February 1984

September 1984

◄ **DO** Guess who's starting to show some individuality with her executive style? Check out the leopard-print scarf.

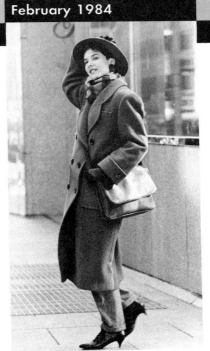

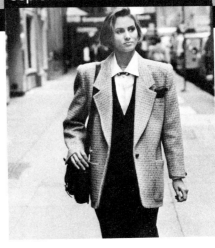

DO This smart winter coat and ► understated accessories make up for all the babushkas, shawls and chubbies we've seen in the past.

DO After assuming the blazer as our own, we took on more man-tailoring. The pocket square and sweater vest are just-right touches.

More Fashion Schizophrenia

Fish or fowl? You be the judge.

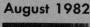

August 1982

December 1985

The perennial dilemma: what to wear over evening clothes in winter. This down coat isn't it.

▶ A woman for all seasons? She's wearing something for every temperature range.

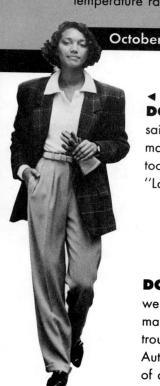

October 1984

◀ **DO** To critics who said man–tailoring made women look too manly, we said, "Look at this!"

DO Even better, ▶ we can wear our man–tailoring with trousers or skirts. Authority comes of age.

March 1985

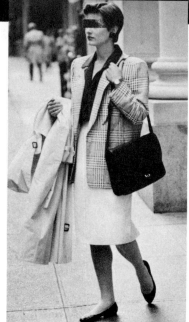

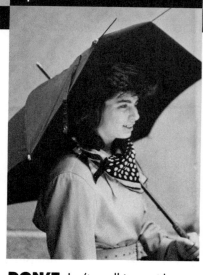

April 1985

DON'T Isn't walking with a broken umbrella the ambulatory version of standing out in the rain?

November 1986

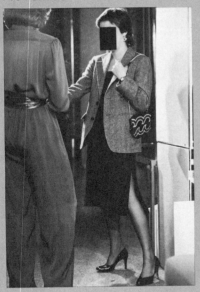

◄ Hint: If you've got tweed and beading in the same outfit, they're probably not compatible.

December 1987

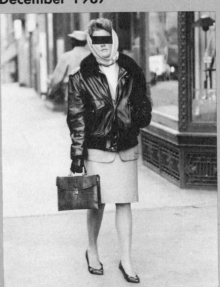

The bomber jacket over a ► business suit? It bombed.

May 1985

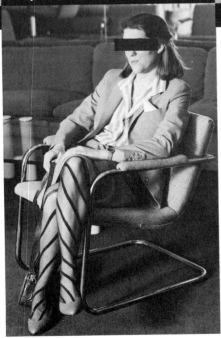

◄ **DON'T** Gross thought: This fashion victim looks as if her legs have been grilled.

DON'T Heart-shaped frames ► may be cute on a six-year-old . . . but on a grown woman—especially one wearing work clothes—they're a coronary infraction.

June 1985

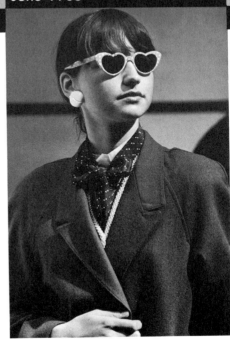

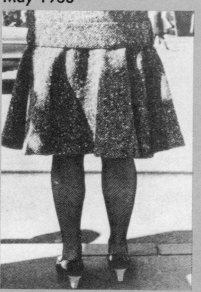

May 1968

Wallpaper for the Legs

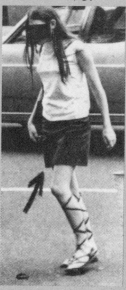

October 1967

◄ Tweed and fishnet: an example of how opposites attract—and not very well.

If she had thought about what ► happened to the original gladiators, she might not have been so willing to lace these on.

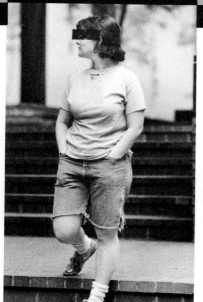

August 1985

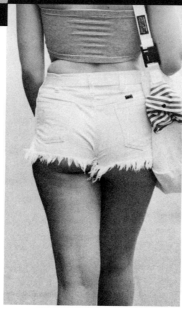

August 1985

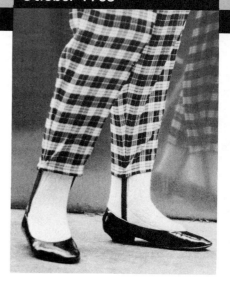

October 1985

DON'T Two ways not to wear jeans (except in your backyard).

DON'T The effect of these too-short stirrups: high-water pants clinging pitifully to the ankles.

March 1969

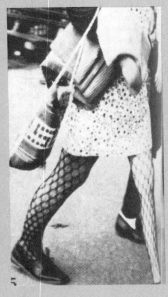

◄ Only by the regularity of the patterning would you deduce that this is not a skin disease.

June 1984

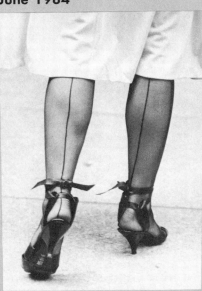

For a Busby Berkeley production number, sure. For the street, *nyet*. ►

February 1986

◄ **DO** The sign of a true classic: If you saw this woman today, she'd still be in style.

DON'T After decades of ►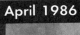 squeezing into uncomfortable pumps, we loved walking to work in sensible shoes. But plain white crews would have looked better.

April 1986

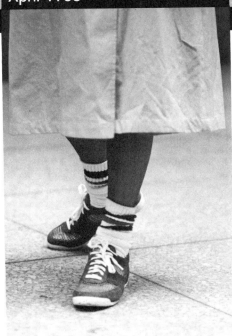

October 1989

Overdo=Don't

Typical Don't–think: Less is not enough. These are the people who spritz on so much cologne your nose hairs singe when you walk within 10 feet of them.

Costume jewelry, yes. ▶
Costume, no.

◀ An Overdo? She's beyond the fringe.

March 1989

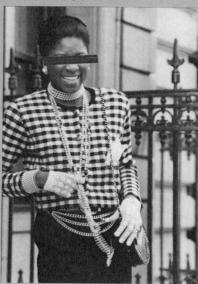

May 1986

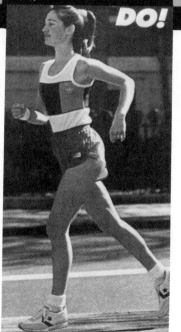

DO!

October 1986

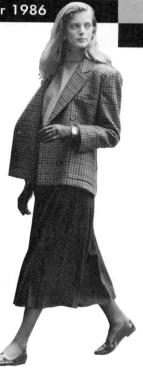

March 1987

◀
DO On the fast track. Working out becomes as important as working late.

DO What's this about one right length? We may have been bound by rules in the past, but no more. ▶

October 1989

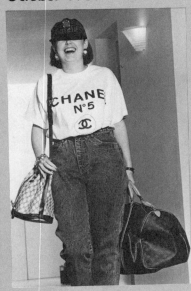

◄ Woman of a million identities. And guess what? They're all fake.

Unless you live at the Arctic ► Circle, this much fur is overkill.

December 1987

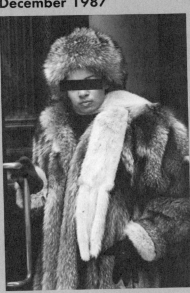

March 1987

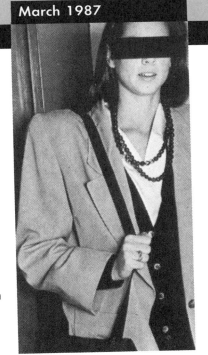

◄ **DON'T** Dressing like a fullback didn't always score points at work . . .

. . . especially when ► shoulder-bag straps burrowed into the padding.

March 1987

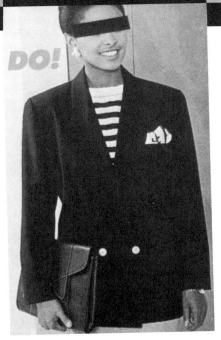

DO Once we realized we could project authority naturally, our shoulders assumed more normal proportions.

October 1986

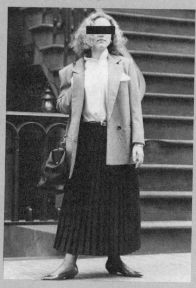

How Not to Wear a Pleated Skirt

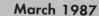

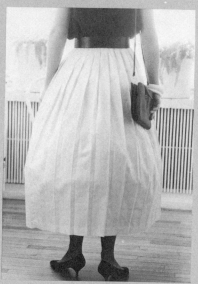

◄ Too much skirt. This woman is swallowed by her pleats.

On what planet is a pleated skirt meant to take a crinoline? ►

June 1987

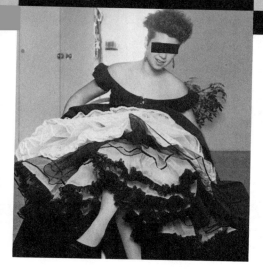

DON'T This crinoline craze was short-lived. Sitting was an ordeal, getting in and out of autos an impossibility. And who had the closet space?

July 1987

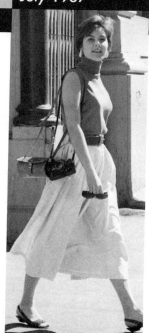

October 1987

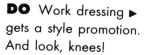

◄ **DO** Have you seen this tourist? Perhaps not: She blends in perfectly with the city scene.

DO Work dressing ► gets a style promotion. And look, knees!

Have You Seen This Tourist?

June 1981

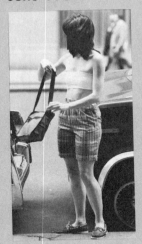

Sure you have. She's the one sight-seeing in beach clothes (okay for a resort town but not for a big city).

◄ Tourist in a tube top. She needed more than sunscreen; she needed a shirt.

She may be wearing beads and shorts, but she's still touring town in her swimsuit. ►

June 1980

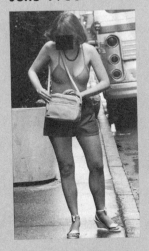

July 1987

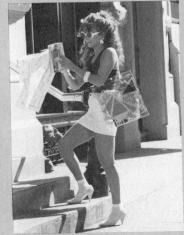

Call this tourist "disco by daylight."

March 1988

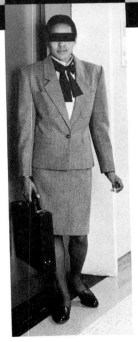

◄ **DON'T** Had we seen this woman in 1980, she would have been a definite Do. Her suit is a classic, but the floppy tie and rigid attaché are here hopelessly out of date.

DON'T In one of fashion's ► typical turnabouts, ripped jeans became something you bought instead of something you threw out. We held fast and said, "Don't."

September 1988

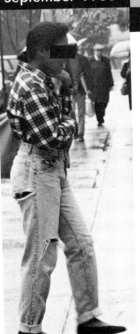

October 1988

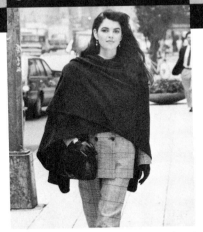

DO A change in the weather? No problem. A big scarf like this was—and is—the perfect way to dress when a blazer isn't warm enough and a coat is too much.

February 1969

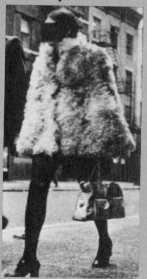

Where's the Bottom Half?

Even when modesty is not the issue, proportion is.

◄ Is this a fur ball on stilts?

Yes, she was carrying a heavy ► load, but pants would not have been that much more of a burden.

March 1969

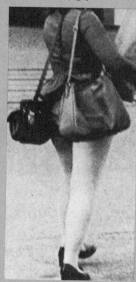

August 1970

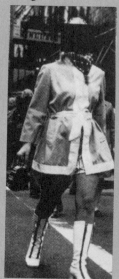

May 1989

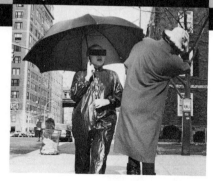

July 1989

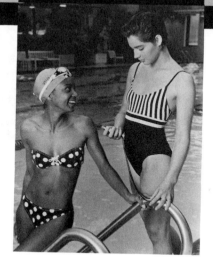

July 1989

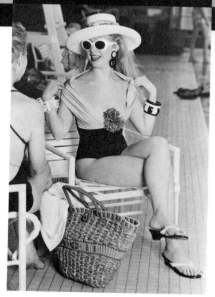

DON'T Bad enough you have to cope with the weather, but umbrellas with a five-foot rib span? Doormen use them, but they keep *several* people dry at once.

DO Just add water. These swimsuits mix form (simple, flattering) with function (actual swimming).

DON'T The *last* thing this woman would want to do is get wet.

December 1971

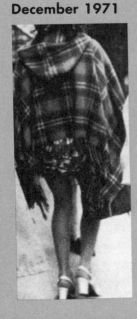

The original go-go era. Fortunately, it's gone.

We call this one ▶ "poncho on pedestals."

July 1985

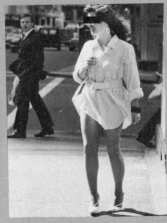

The big shirt: Not having to tuck it in was no excuse for skipping the bottom half.

November 1989

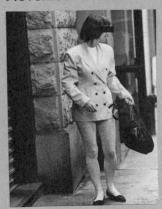

This is when tights first took the place of pants. But who said that panty hose should take the place of tights?

September 1989

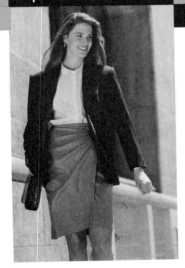

DO Career dressing gets a twist. Skirts are draped and shaped but still professional as office attire evolves.

October 1989

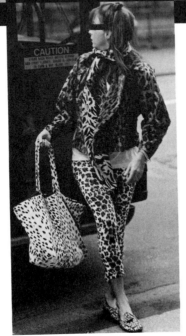

◀
DON'T This woman has obviously lost her fashion sense, although her animal instincts seem to be working overtime.

DO Tights take the ▶ place of trousers. We were so comfortable in our dance leggings and running tights that we adopted their lean style for weekend wear.

November 1989

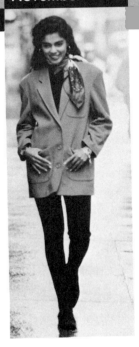

The 90's

Perhaps because it's the decade that will close out the century—indeed, the millennium—the nineties is shaping up as the era of recycling. There's ecological recycling, of course, but there also has been a recurrence of the issues and trends that we—and our mothers—have grown up with. We've gone from go-go girls to fly girls; from Laurie Partridge to Grace Van Owen; from rap sessions to rap music. Add to them the reruns, repeats and remakes of everything from *The Addams Family* to *Star Trek* and it feels like déjà vu all over again.

Always cyclical, fashion has been looping about with greater velocity as the century draws to a close. Shirtwaist dresses are back. So is the shirt. We've gone from platforms to Birkenstocks to platforms *and* Birkenstocks. And then there's the yin and yang of hemlines. The big difference this time around is that we'll choose whether or not we want in on the cycle. Short? Sure. Long? If you like. High heels? Low heels? Your move. Pants? They're so comfortably a part of our wardrobes that they're no longer an issue.

Freedom of fashion is one slice of the larger pie. We're on to the rest of the pan. This is called having your cake and eating it, too.

January 1990

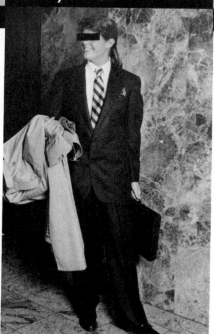

◄ **DON'T** We're all for freedom of choice—in life as in fashion—but this woman takes man-tailoring too far.

March 1990

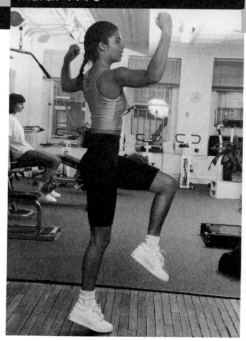

DO What we learned from ► weight training, circuit training and aerobics over the past few years: Real physical strength gives us confidence.

Unfit to a Tee

May 1990

These teetotalers add up to a big zero.

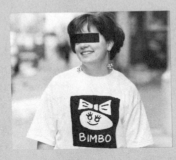

If it looks like a wet T-shirt when it's dry, it's too tight.

An intelligent life form inhabits this T-shirt, but you'd never know it.

Shoulder pads on a football jersey, yes. On a T-shirt, comic relief.

May 1990

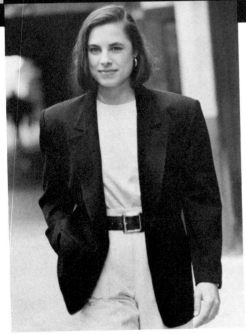

◄ **DO** While most of us never got behind the idea of wearing underwear in public, who among us hasn't adopted the T-shirt as a wardrobe staple?

March 1991

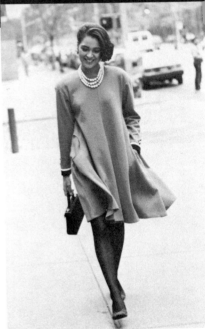

DO With its full, swingy shape, ▶ the trapeze dress is the opposite of the uptight work suit.

Your Turn, Guys

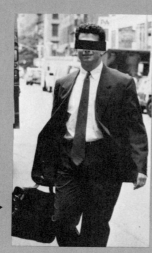

It's about time we showed you what you really look like. Consider this a public service—and not a moment too soon.

. . . Mr. Extension. ▶ Is there a subliminal message here?

You mean he dressed like this by *choice*? Surely it was a slipup.

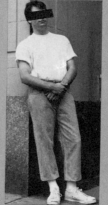 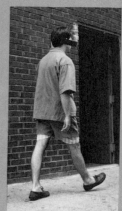

Tying one on: Mighty Midget meets . . .

Expecting a flood? Who says hemline indiscretions are limited to women?

April 1991

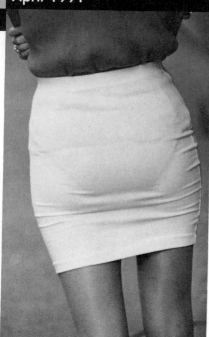

October 1991

◀ **DON'T** The little stretch mini put some of us in a bind.

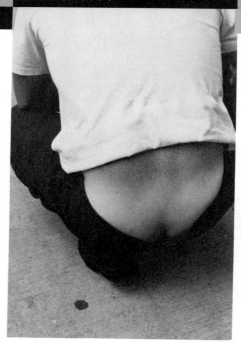

DON'T Yo, buddy, get a ▶ belt—and use it! This is the first time we took aim at men (but it won't be the last).

Two of a Kind

January 1969

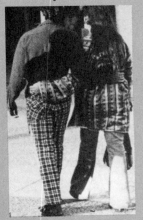

This was the era of ''Do Your Own Thing.'' What they did was clash.

Increased wannabe sightings are a sign of the times.

February 1991

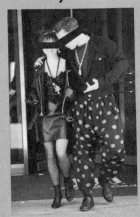

February 1991

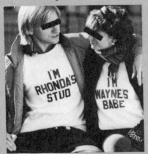

Wayne, Rhonda? Are you joined at the hip, too?

February 1992

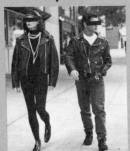

Well, let's hope she's the one driving the Harley.

October 1991

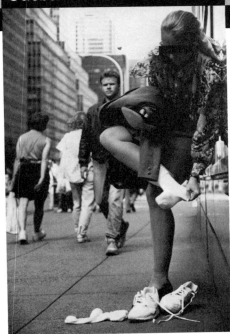

◄ **DON'T** There's nothing wrong with walking shoes when you're hoofing it to work. But this woman needs to find a more discreet place than the sidewalk to change into her pumps.

DO Ever notice how some ► couples dress as if they came from different planets, while others are done up like twins? This young professional couple is in sync without losing their individuality.

February 1992

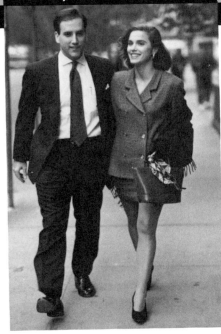

Cheeky about getting in those miles.

Gym Duds

No one says you have to put the same amount of thought into dressing for your workout as in dressing for work, but do *think* about it.

March 1990

Don't sprain a nail!

March 1990

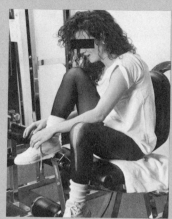

These tights aren't what we had in mind when we suggested she go for a run.

April 1992

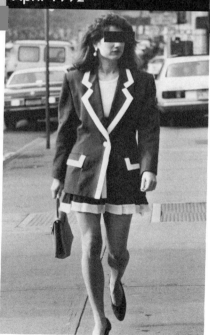

June 1992

◄ **DON'T** Dressing for work may have loosened up, but the bottom line is, well, the bottom line. Here it's too short.

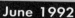

DO If you can wear shorts to ▶ work, this is the way to go: an abbreviated pantsuit. If, on the other hand, you look as if you're dressed for an afternoon of Frisbee, the word that comes to mind is DON'T.

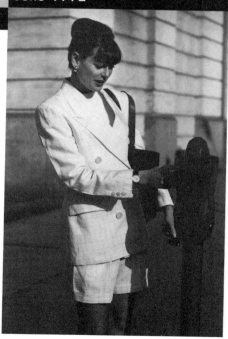

September 1982

The Way We Worked

If there's a capsule history of how our life has changed in the past decade, it's how we dress for work.

◄ This was a "businesslike and sophisticated" suit.

Style! There's a woman under ► that suit (but she's discreet about it).

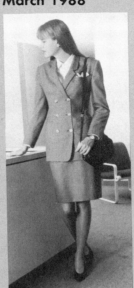

March 1988

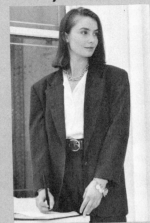

January 1990

Man-tailoring comes of age. Now who's wearing the pants?

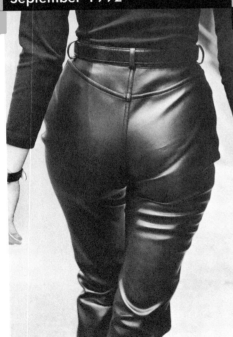

September 1992

◄ **DON'T** Fashions come and fashions go, but here's a constant: panty lines. And you know what they are.

The Ultimate Don't: Sometimes ► it's not what you put on that sends you careening into Don't-hood. Take the toilet paper stuck to the bottom of this woman's shoe: instant wipeout.

The Do
Hall of Fame

All the things a Do has—style, self-assurance, independence—these women have in spades. That's why we named them to *Glamour's* ''Do Hall of Fame.'' What we like about these women as role models is their diversity of style. Yet there is a constant: Whether she's wearing jeans or an evening dress, boots or high heels, each is a woman who is comfortable in her clothes. You may not be in her shoes, but you can wear that attitude.

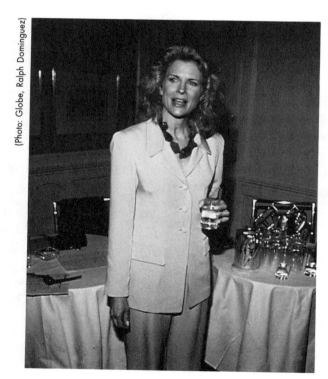

(Photo: Globe, Ralph Dominguez)

Candice Bergen: She (and her alter ego, Murphy Brown) look stylishly, classically, effortlessly dressed.

Diane Sawyer: We admired her sleek professionalism way back in 1970. Call her a Déjà Do.

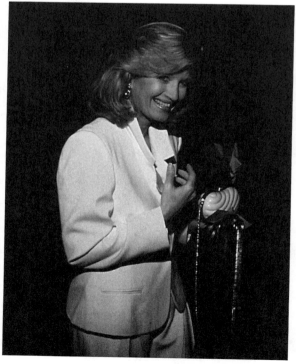

(Photo: Globe, Ralph Dominguez)

k. d. lang: Hers is not a look for everyone, but she pulls it off.

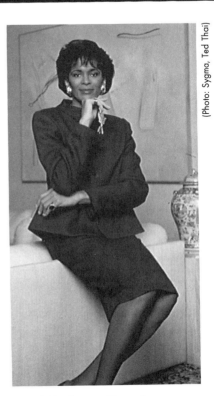

Katharine Hepburn: A role model in the forties, when women first started wearing pants, she's a classic in any era.

Faye Wattleton: Her glamour never got in the way of a difficult job.

Liz Claiborne: This fashion icon is an individualist, from her cropped hair and owl glasses to her cowboy boots.

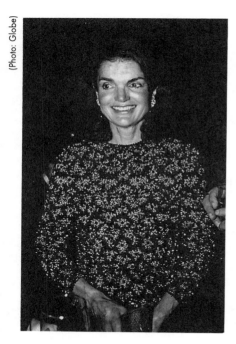

(Photo: Globe)

Jacqueline Onassis: Look no further for proof that money and taste are not incompatible.

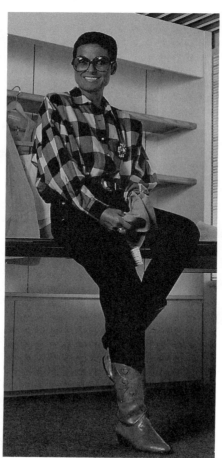

(Photo: Outline Press, E.J. Camp)

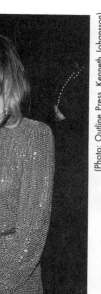

(Photo: Outline Press, Kenneth Johansson)

Michelle Pfeiffer: In Tinseltown her glitter has a low-key luster and an Italian name—Armani.

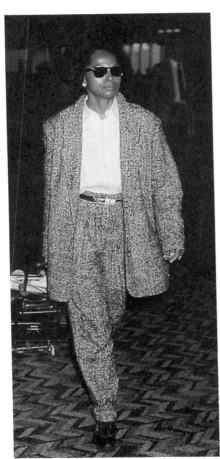

(Photo: David Parker, Globe Photos)

Diana Ross: Her shimmering
on-stage persona is just part of
her style. In real life she's
real—and look, athletic shoes!

Joan Rivers: Persistence pays off—a gawky comic grew into a
woman of style.

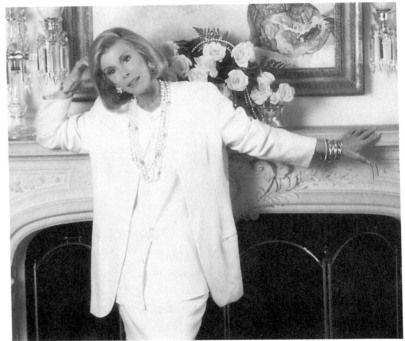

(Photo: Outline, Gary Moss)

JOANNE MATTERA is the fashion features editor at *Glamour* where she interprets styles and trends for millions of readers each month. In the seven years she has been with *Glamour*, Mattera has produced many "Dos & Don'ts" columns and two anniversary articles, becoming in the process the unofficial "Dos & Don'ts" historian of the magazine. In a more serious vein, she has developed columns that track the political trends ("G Notes"), fashion trends ("Fashion Fax"), and give readers an inside look at consumer issues ("Truth in Fashion"). A visual artist outside of the office, Mattera maintains a painting studio in New York City.